SEKOTO

THE ART OF GERARD SEKOTO

SEKOTO

THE ART OF GERARD SEKOTO
BY BARBARA LINDOP

PAVILION

First published in Great Britain in 1995 by
PAVILION BOOKS LIMITED
26 Upper Ground, London SE1 9PD
Text copyright © Barbara Lindop 1995

The moral right of the author has been asserted.

Designed by Nigel Partridge

A CIP catalogue record for this book is available from the British Library.

ISBN 1 85793 461X

Printed and bound in Singapore by Kyodo

2 4 6 8 10 9 7 5 3 1

Typeset in Bauer Bodoni

This book may be ordered by post direct from the publisher.
Please contact the Marketing Department.
But try your bookshop first.

For our mothers, Anna Serote Sekoto and Barbara Fahey Sceales

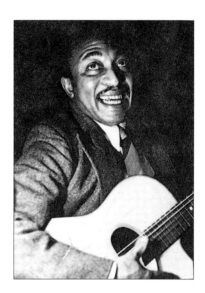

AUTHOR'S NOTE

In 1988 Gerard Sekoto's art was re-introduced to South Africans by the book *Gerard Sekoto*. The book is now out of print. It comprised 289 colour reproductions of Sekoto's paintings and an autobiographical letter written to me by Sekoto. This particular seventy-page letter emerged from a lengthy correspondence between myself and Sekoto which had begun in 1985.

As mutual trust developed, Sekoto began to confide his innermost thoughts and to express his personal philosophy. He reflected on the influences of his early life and the development of his artistic talent. He described the difficulties he experienced during the forty-six years of his voluntary exile in Paris. Selected passages from this correspondence are included in this new edition.

The publication of the first edition was made possible by generous sponsorship, in particular from the French and Swiss governments, Mr Kim Santow, Sydney, Australia,

and South African corporations. Mona de Beer edited the text and Trevor Matterson photographed the paintings. Peter Johnson, through the courtesy of De Beers, photographed Sekoto in Nogent-sur-Marne, in his bedroom at the Old Age Home for Artists. One of these photographs is included in this new edition.

I would like to express my gratitude to Mr Colin Webb of Pavilion Publishers for making this second edition possible. He was inspired by the film on Sekoto made by Bandung Television for Channel 4, UK, partially funded by Ned Bank, South Africa. It was produced by Alex Laird and directed by Ginny Heath. I would also like to thank Emma Lawson, Nicky Granville, Marianne McPhie, Fran Swan, Angela Caccia Lloyd, F. C. and Rayda Bekker for their generous assistance. The uncredited photographs of Sekoto's paintings featured in this book were all taken by Trevor Matterson.

The black South African artist, Gerard Sekoto, died on 20 March 1993 in Nogent-sur-Marne, a neighbouring suburb of Paris. Born in 1913 he had been in self-imposed exile in France for forty-six years, having left South Africa in 1947 to further his studies in art.

My friendship with Sekoto developed through a lively correspondence that began in 1985. We finally met in 1988. Those years of exchanged letters allowed me to know Sekoto in a remarkable and intimate manner, and enabled me to publish a book on Sekoto's art in 1988.

When our correspondence began, Sekoto was a patient in the Hôpital Dupuytren in Draveil, near Paris. He was recovering from injuries sustained in an accident in 1983, and was recuperating slowly. He was depressed and frustrated, but as I began sending him photographs of paintings that I had discovered, he became increasingly stimulated and memories of happier times came surging back. In his letters he used rich and imaginative language, and he had an enormous talent for communicating and sharing his feelings. Hospital rules did not allow him to paint and his letters became more and more an expression

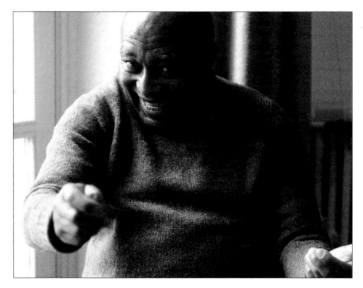

Gerard Sekoto, Paris, 1988. Photo: Peter Johnson. De Beers © 1988

of his frustrated artistic talents.

In 1987 Sekoto was at last able to leave hospital. A place was found for him in the peaceful and pleasant surroundings of the Old Age Home for Artists in Nogent-sur-Marne, outside Paris. Here he began a new life and started painting and drawing enthusiastically, often interrupted by admirers coming to pay him homage.

His funeral revealed more to me about Sekoto than I had ever known before. His secretive nature and his desire for privacy, honed by years of exile, meant that even his closest friends did not know each other. Amongst his personal possessions were over 1,000 letters written to Sekoto by his friends and family. He had maintained close links with exiles in France and the United Kingdom as well as with other academics and intellectuals.

His friends and acquaintances gathered at the funeral parlour in Nogent-sur-Marne to pay their last respects. He lay in an open coffin, looking peaceful, strong and resourceful. A thick, white, flickering altar candle stood by his side. French convention entailed a long wait in these rooms, but finally the body was covered and the coffin was carried by family members and friends to the awaiting hearse. It was a brisk spring day with blue skies; green leaves were just beginning to burst forth and daffodils and jonquils lined the suburban streets.

It had been agreed that, as Sekoto was a committed agnostic, no religious ceremony would be performed. People gathered around the freshly dug grave. Sekoto's friends took turns to read from their own poems or those by Sekoto, while others gave moving accounts of their friendships with him and praised Sekoto's art and his extraordinary personality. An exiled black South African saxophonist played a haunting melody as Sekoto's coffin was lowered into the ground.

The wake was held at Sekoto's favourite bar, Le Pronostic, in Nogent-sur-Marne. A poster of one of his recent exhibitions in South Africa hung on the entrance door and three of his sketches, given to the owner, decorated the wall behind the counter.

Sekoto's drinking companions, many immortalized in his sketches, were soon chatting to the crowd of friends, academics, ambassadors, musicians and artists. The common theme was how each had fallen out with Sekoto at different times. Some blamed his alcoholism, others described bitter arguments followed by Sekoto refusing to take their phone calls. Some even blamed me. Nevertheless, the atmosphere in the bar that day was magical. New friendships were forged, animated discussions took place and there was no doubt in anyone's mind that,

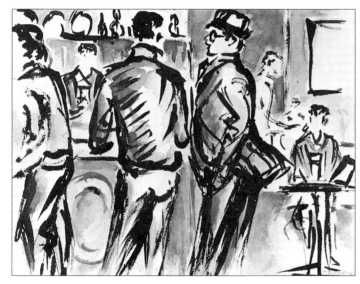

Sketch of 'Le Pronostic' 1988

Unlike many of his contemporaries Sekoto's work was recognized during his lifetime, and details of his life were recorded. Forty-six years of apartheid, coupled with the racism of the early twentieth century, make the assessment of the real history of South African art overwhelmingly difficult. Apartheid permeated South African society, influencing attitudes outside politics, even shaping scholastic opinions. Apartheid's dogma was often accepted as the truth and one outcome was that white South African artists' achievements were readily acknowledged while those of their black counterparts were totally overlooked. There is little documentation on the lives of black artists of the time. Consequently the value of Sekoto's correspondence is all the more significant.

however complex and perverse Sekoto had been, he had had an enormous impact on all who knew him. His vital personality, his sense of humour, his sensitivity, warmth, intelligence and artistic sensibility were the characteristics that everybody acknowledged. That evening he was forgiven for the occasionally suspicious, difficult, obstinate and stubborn side of his nature.

The combination of apartheid and self-imposed exile conferred a mythical status on Sekoto which still exists. The frankness and honesty of his letters create a balance between his view of himself and the forces that developed and shaped his career. While in Paris, Sekoto continued to write to his family and South African friends in his mother language, Pedi or Northern Sotho, and communicated

with his French friends in French. Sekoto's letters to me, and his use of his second language, English, offer an intimate understanding of his character. They complement the humanity of his pre-exile paintings: his lack of sentimentality, his commitment to truth, a poignant realism and an acute awareness of the heroism revealed in ordinary human life.

Sekoto's work is set against the background of a vigorous intellectual fight for recognition and status which occured earlier this century amongst the black intelligentsia in South Africa. This thinking is evident in the writing of black authors such as Sol Plaatje, (1876–1931), H. I. E. Dhlomo (1903–56), Peter Abrahams (born 1919), Can Themba (1924–68) and others. They strongly desired recognition, and expressed their frustrations and aspirations.

The strong motivating force behind Sekoto's work was

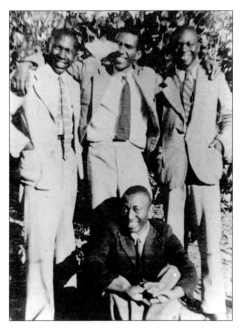

Ndebele, Makenna, Mancoba, Sekoto

his desire to use art to communicate through the 'interlinking chains of humanity'. He tried to rise above racism, and hoped that his paintings would generate understanding between the many different peoples in South Africa.

Sekoto's work did not exist in a vacuum. His contemporaries included J. K. Mohl (1903–85), Gerard Bhengu (born 1910), Ernest Mancoba (born 1910), George Pemba (born 1912) and Moses Tladi (1906–69). With the exception of Tladi, who worked as a gardener, all these artists were trained as schoolteachers. By the standards of the 1930s they were well educated people.

Sekoto spent four years teaching at Khaiso School, near Pietersburg in the northern Transvaal. Ernest Mancoba who also taught at the school, and Nimrod Ndebele, a playwright, encouraged Sekoto to paint. Mancoba showed

Sekoto paintings by Van Gogh, and used Van Gogh's life to emphasize that an artist's life was indeed a struggle. In 1937 Mancoba won the first prize in the May Esther Bedford competition, open only to black South Africans. In 1938 George Pemba won the competition and Sekoto received the second prize. Mancoba who was planning to leave Africa for Paris, suggested Sekoto should accompany him to France but Sekoto hesitated and Mancoba left on his own in 1939. Mancoba subsequently achieved considerable recognition as an artist in Europe. He married the Danish artist, Sonja Ferlov, and both became active participants in the Cobra group. George Pemba remained living in South Africa in Port Elizabeth in the eastern Cape. Now aged eighty-two, he still paints and receives numerous visitors coming to pay homage or to interview him.

Sekoto openly acknowledged his introduction to Van Gogh's art by Mancoba but firmly denied having ever been influenced by formal training or exposure to other artists' work. He did not try to conform to stylistic traditions or comply with conventional taste, but instead looked to the people around him for inspiration. His pre-exile paintings are spontaneous and realistic, and although his intuitive sense of colour links his work to the Post-impressionists, he is separated from them by his subject matter. Even the minor commercial success he achieved while living in South Africa did not affect his style. His individuality and strength were recognized at the time, as we can see from the following editorial published in 1949 in *Inkundla Ya Bantu*, a black newspaper:

> This has not driven him to the false position where, to make a living, he has had to pander to the vulgar tastes of some of those who produce art in the country. He has consistently refused to see the African as a picturesque creature. To him the acquisition of more skill has meant he must paint with deeper feeling for and active sympathy with that African whose soul is daily being crushed and bruised in his own Africa.

Gerard Sekoto was born on 9 December 1913 at Botshabelo, a German Lutheran Mission Station in the eastern Transvaal, where his parents, Andreas and

Anna (née Serote) were also born. His father trained as a schoolteacher and later became an evangelist.

When Sekoto was five years old, his father was posted by the Lutheran Church to their mission school on the farm Wonderhoek, also in the Middelburg District. Here Sekoto spent his most formative years. He nurtured the memories of his rural childhood for the rest of his life, and in many of his letters he dwells at great length on the experiences of his youth and early family life. The love and security he was shown as a child were a source of solace and strength during the difficult years of his exile.

At the age of five he began modelling in clay, and later took to drawing in chalk on his older brother's school slate – until he had a slate of his own. When he was eight he attended the mission school, where pencils and paper were available and he realized that he had a special talent for drawing. Some years later, he found an old sketch book belonging to his father, with crayon drawings. This was a revelation to Sekoto who had not known that coloured crayons existed. He began to draw; initially his subjects were his own family and then visitors who came to their house. For the rest of his life, his subject matter focussed on people.

At the age of seventeen he was sent to the Diocesan Training College, Grace Dieu, (now named the Setotolwane College) near Pietersburg to train as a teacher. His first post was in an Anglican primary school at Khaiso, in the same area, where his fellow teachers included Nimrod Ndebele and Ernest Mancoba. An example of Sekoto's early watercolours painted at Khaiso is *Lutheran Chapel at Botshabelo*.

When Sekoto's father died in 1938 he no longer had an obligation to fulfil his father's wish for him to be a teacher, and he was free to pursue his own direction. In 1939 he went to live with cousins in Sophiatown, Johannesburg. As he was wandering the streets looking for work, he came across a general trading store selling poster colours and paintbrushes. It was then that he decided to devote himself entirely to painting and he began to experiment with poster paints on pieces of brown cardboard, which were inexpensive and readily available, such as *Poverty in the Midst of Plenty*. A friend encouraged Sekoto to show his work to

Brother Roger Castle, a teacher at St Peter's Anglican Secondary School in Rosettenville, Johannesburg, which was open to black students. Brother Roger was so impressed with Sekoto's talent that he offered him free board and lodging at the school, enabling him to attend the school's art classes. Soon afterwards he was offered a temporary six week's teaching post, replacing a permanent teacher who was absent on sick leave.

Brother Roger introduced Sekoto to the white South African artist, Judith Gluckman, who was also teaching at St Peter's, and who invited Sekoto to her home and offered to teach him to use oil paints. Later Sekoto wrote:

> She invited me to her studio where I went about five or six times. She showed me how to mix oil colours on the palette, use the palette knife and different kinds of brushes. She showed me how to use the easel. She also showed various types of canvases prepared and otherwise. She demonstrated how to put on the colour, either thick or thin. She told me about the process of preparing the canvas although we did not

actually do it. She also showed me how to clean the brushes and the palette.

Brother Roger also organized Sekoto's first exhibition at the Gainsborough Galleries in Johannesburg in 1939. An astonished newspaper critic said:

> The paintings by Gerard Sekoto are the outstanding feature of this exhibition. He could take his place amongst the 'moderns', particularly the French school for his canvases are marked by extremely good colour and drawing.

The following year, Brother Roger persuaded Sekoto to submit paintings for an exhibition at the South African Academy, the showcase for contemporary South African art. He exhibited two paintings, both scenes of Sophiatown. Sekoto wrote:

> My efforts when I was in Sophiatown was to arouse the consciousness in our own people of the horrible

conditions in which they lived. Such an awakening would create power and weight to demand the right and knowledge to be able to live like everyone else in the country.

Many of Sekoto's early depictions of Sophiatown, for example, *Interior Sophiatown*, *The Soccer Game* and *Cyclists in Sophiatown* have a romantic, lyrical quality, overriding the actual reality of the sordid surroundings. In 1941 and 1942 Sekoto's paintings were again accepted for exhibition at the South African Academy, and in 1942 he also exhibited again at the Gainsborough Galleries in Johannesburg. By this time Sekoto was longing for wider exposure – he wanted to discover Cape Town, and he started to plan his departure for Paris.

Brother Roger introduced Sekoto to George Manuel, a journalist living in District Six, a suburb of Cape Town. Manuel arranged for Sekoto to live with his mother and sisters, in a house opposite the Roeland Street jail. This building was a source of great inspiration to Sekoto. *Prisoners Carrying a Boulder* and *Prison Yard* depict the comings

and goings of the prisoners and their warders. Sekoto's political comment is implicit in his compositions: he seldom portrayed white people in his paintings and only then as foremen or warders. *Houses: District Six*, *Children Playing* and *Portrait of a Cape Coloured School Teacher – Omar* identify the kind of environment and the people with whom Sekoto lived and became acquainted.

In 1943 three of Sekoto's paintings entitled *The Red Curtains*, *Brown Girl* and *Boy and the Candle* were included in the fifth anniversary exhibition of the New Group, at the Gainsborough Galleries. Founded in 1938, the New Group was an association of white South African avant garde artists whose main objective was to upgrade the overall standard of South African art and increase public awareness.

In 1945, Sekoto moved to Eastwood, a township near Pretoria, where only black people were officially allowed to live. He shared a house with his mother and stepfather, and his brother, Bernard and his wife, Mary Dikeledi. Like Sophiatown, District Six, Khaiso, and many other communities in South Africa, Eastwood was bulldozed to the

ground by official decree in the early years of the apartheid government, and the residents were forced to move to remote and inaccessible areas with limited facilities. Sekoto's paintings provide important historical documentation of these destroyed communities.

During 1945–47 Sekoto painted prolifically in Eastwood. These were the 'golden years' of his art. He concentrated on oil paintings, all of which displayed a new found confidence and maturity. His intuitive and acute sense of colour combined with an assured brush stroke characterize a series of masterful paintings. Eastwood and its surroundings provided inspiration for these compositions, and there he was able to capture the poignant and transient moments of everyday township life.

Sekoto wrote about his Eastwood painting *Sixpence a Door*:

Our home was close to the playing ground which was in the centre of the township. On Sundays Zulu dancers would come and put up a tent. People would be eager to see inside but many would hang around outside with curiosity as they did not have the sixpence to spend.

He set up his easel and painted the scene in front of him. The passers-by were far more interested in the Zulu dance spectacle than in watching Sekoto paint.

Sixpence a Door was included in the exhibition *Contemporary South African Paintings, Drawings and Sculpture* which travelled between 1948 and 1950 to Belgium, the Netherlands, France, Canada, the United States of America and London. At the opening at the Tate Gallery, the Queen Mother stated that the painting she admired most was 'the one by the native artist'. The next day newspaper headlines acclaimed Sekoto's success, launching him momentarily into the limelight. *Sixpence a Door* is probably the best known Eastwood painting and in 1991 it was sold at an auction for 186,000 South African rands, (about £34,000), at that time the highest price ever paid for a painting by a living South African artist.

Whilst living in Eastwood, Sekoto also painted one of his most politically explicit compositions *Song of the Pick*. It

sion, the composition of the photograph is altered to highlight the contrast of the physical strength of the workmen and the weakness of the white foreman.

Sekoto was emotionally very secure during his Eastwood sojourn. He was surrounded by his close knit family and painted a magnificent series of family portraits, amongst these *The Proud Father* depicting his brother, Bernard, with his eldest daughter, Naky, on his knee. In the same

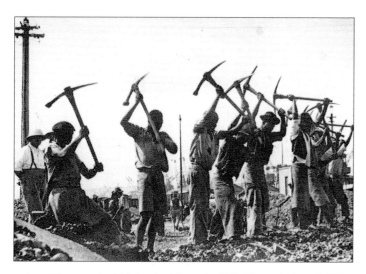

ABOVE Photograph which inspired Song of a Pick. *Photo: Andrew Goldie*
RIGHT Sketch of Song of a Pick, *1960*

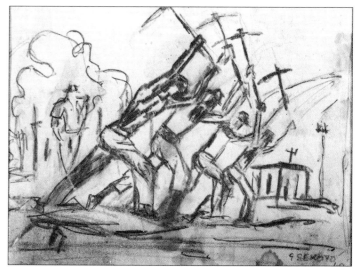

was based on his 1940 watercolour study which had been inspired by a black and white photograph he had acquired and which he kept with his personal possessions all his life. During the sixties he made several small ballpoint sketches, some based almost literally on the original photograph. Later in the 1980s he painted a couple of large oil paintings based on this theme. In the original 1946 Eastwood ver-

house he painted Anna, his much loved mother, sitting on a bench next to Paulus, her second husband. *Portrait of Anna, the Artist's Mother* depicts her sitting on the same bench. The portrait is painted in a delicate palette of blue, brown and yellow. She is deeply absorbed in her sewing, and an atmosphere of harmony and stillness pervades the painting. No member of the family was left out; Mary Dikeledi Sekoto, Bernard's wife, is shown to be a strong and resilient personality and Bernard is shown greeting a visiting evangelist at the front door.

By 1940, public recognition of Sekoto's talent as an artist had already begun to grow. That year the Johannesburg Art Gallery which houses one of the most important collections of art in South Africa, bought his painting *Yellow Houses – Sophiatown*. The gallery's founding policy was to include only works of international quality, and until the 1980s Sekoto's work remained the only painting in the gallery by a black South African artist. The same gallery had turned down Sekoto's earlier application to be a floor cleaner because of his skin colour.

Sekoto's patrons in the early 1940s were mainly Jewish intellectuals. Far from encouraging him to stay in South Africa, their financial support and recognition of his talent enabled him to acquire the means and confidence to plan to leave the country in 1947. In one of his letters to me in 1991, Sekoto recalled the mortification that circumstances of life had inflicted upon him:

> You have never known what it is to be humiliated deep into the very mind as an individual as well as being a member of those people who are globally undergoing that same humiliation through the guilt in the colour of their skin. Therefore deemed as the oppressed. I left my land of birth on my own means and will. There where I pride my roots and where my mother first brought me to land upon these perplexities of life. Where I have become a citizen in a country where the law does not permit me the full citizenship.

The tragic irony of Sekoto's exile is that having realized his dream of being able to leave South Africa, he was forced to pay a high personal price. His art, which had drawn such

poignant inspiration from the environment which he knew so well, slowly lost its basic strength and character. His pre-exile paintings reveal complete involvement with his subject matter. In exile he continued to recreate South African subject matter but he failed to identify himself with his work. It was as if he felt obliged to paint what the public expected of him as a black South African artist. As the years went by Sekoto was not able to remember the vivid

Sekoto, assistant cook

and particular detail that personalized his early work and made it so remarkable: even his powerful use of colour and its contrasts faded into an ordinariness in his later years.

When he first arrived in France, Sekoto believed that English was a universal language and was shocked to dis-

cover how few French people spoke English. Not only did he struggle to communicate with them, he also battled to understand their cultural differences. He was a naturally gifted musician, and had learnt to play the harmonium and the piano. In order to survive financially, he found work playing the piano in Parisian jazz bars. His appreciative patrons plied him with a variety of drinks, encouraging him to continue playing into the early hours. This job, and the alcohol which seemed to lessen the difficulties of life in Paris, meant that within months of living there, Sekoto had become alcohol dependent.

In Paris Sekoto's artistic style and technique changed dramatically, but his basic subject matter remained South African. Sekoto commented,

18

my subject matter was still of South African life as I had decided to hang on to it so as not to lose roots. I had made my little sketches in the Parisian streets and bars to put aside for later when I had gathered myself into the atmosphere as I would feel it. It was difficult and still is to remain oneself in the enormous jungle of various characters all gathered together in this world wide reputed city of arts.

The pencil sketches to which Sekoto refers – of people emerging from the Metro, sitting in cafés, listening to music, of pigeons, streets and buildings – were personal, private and small enough to conceal in a pocket if necessary. They were not intended to be seen, but they share a similar, delightful spontaneity with his early South African drawings.

Sekoto's need to be 'himself' explains the dramatic change that took place within his stylistic development. His African scenes enabled him to remain 'African'. His sketches, on the other hand, show that he was observing and drawing local Parisian scenes. It was as if he lacked the confidence to develop the sketches into paintings in the way that he had done in South Africa. This insecurity, his difficulty in finding a suitable place to live and work, and his inability to relate closely to his subject matter as he had done previously, inevitably affected his style.

He attended the Académie de la Grande Chaumière during 1948, but his attendance there was sporadic. Several nude studies in pastel recall this period of his artistic development. His first one-man exhibition at the Galerie Else Clausen in 1949 was a failure. An argument between Sekoto and the gallery owner, Raymond de Cardonne, developed into a fight. De Cardonne called the police and Sekoto was admitted to St Anne's psychiatric hospital. De Cardonne, mortified by his impulsive actions, went to visit Sekoto shortly after his admission and was shocked to find that Sekoto had been strapped down to his bed. He later returned with a gift of charcoal and drawing paper. During the three months in hospital, Sekoto made a remarkable series of drawings of his fellow patients, many of whom were World War Two veterans. De Cardonne sent an American client to visit Sekoto; she arranged for a journalist to interview him

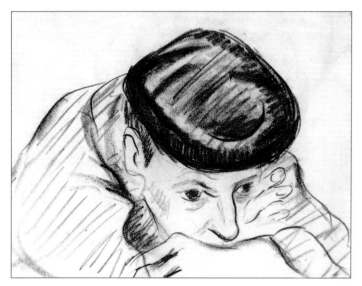

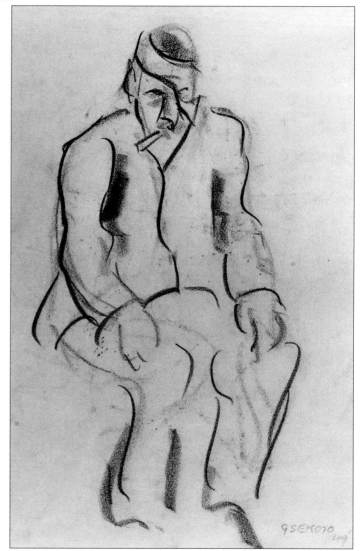

ABOVE St. Anne's: The Black Beret
RIGHT St. Anne's: Sore Eye

for *Time* magazine. An article about Sekoto appeared in 1949 (volume 54, No. 6, p.29). Sekoto comments about these drawings:

I did a lot of drawings of these very co-operative models who had no suspicions of any sorts. There

were some who were particularly willing to pose; they were mentally troubled not lunatics. But the truth could be recognized from the sketches that the mental state of these patients was not entirely normal.

The drawings are striking in their empathy and insight into conditions of loneliness and depression, and Sekoto's use of line is deft and self-assured. The diagonal shading suggests a sense of imprisonment. He also captures the typically

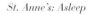

St. Anne's: Asleep

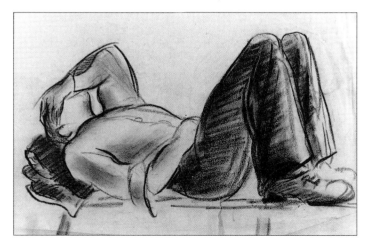

Gallic characteristics of his fellow inmates with a depth of observation as profound as that in his pre-exile work. These studies are exceptional: intimate, direct and often harrowing in their intensity.

When Sekoto was discharged from St Anne's Hospital, Raymond de Cardonne introduced him to Marthe Hennebert. She had been found walking in one of the poorer districts of Paris by the German poet and man of letters Rainer Maria Rilke.

Rilke had 'rescued' Marthe from a Parisian brothel and befriended her. Rilke's biographer, Nora Wydenbruck, called her 'a true daughter of the people',

amazingly natural, healthy uncontrolled and wild – one could have imagined her fighting on the barricades in the French Revolution. At the same time she was gifted with profound human insight, delicacy and tact. She was precocious and innocent, hardened by misery and yet amenable to every gentle influence. She had so much understanding for Rilke's poems that he would read them all to her.

Sekoto rented a studio space in Marthe's apartment at 15 Rue des Grands Augustins. Their relationship slowly blossomed into a romance which led to their living together for thirty years. In response to questions about Marthe's relationship with Rilke and about Marthe herself, Sekoto wrote:

She was an invalid who from time to time needed hospital care. I would take care of her and the apartment. (She had driven out her tenant James Baldwin because he had no money). She had worked for Jean Lurçat and later married, then divorced him. He had enlightened her understanding of the Arts.

Although Marthe was in the world of arts she was wild in meeting and conversing with others. She had only one close friend with whom she would spend hours conversing. This friend always brought fruit and chocolates. Marthe never once thought to offer

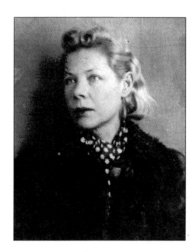

Marthe

tea or coffee. Even the fruits and cakes would be kept for the two of us later.

Whenever friends or customers of mine came to visit, I would introduce her to them, but she would immediately disappear into her room where she would remain until they left. Any effort I made to attract her would be in vain. Although she did not always approve of my behaviour she needed my presence and she did have some confidence in me. Above all she adored my art. She was always quite frank. She would say what she liked and what she didn't like and give her reasons. Generally she was very interested in looking, hearing and reading whilst remaining closed in her nest.

She was quite impenetrable and aware of the savage side of her nature yet she was highly sensitive towards all the arts. She required no particular education into something entirely new to her. At a glance she already knew her feelings. If someone else went

on further to explain the original meaning, it would not succeed in getting her off the trail. She could not draw a straight line or produce a correct musical note. She could from time to time write adorable short letters.

Marthe highly esteemed R. M. Rilke whom she considered to be a god. On the other side this poet had been intoxicated by her charms. To him she had that image of an untouchable angel. By the time I got to live with Marthe at No. 15 Rue des Grands Augustins, Marthe had not retained all of those intoxications, which had inspired the great German poet.

Sketch of Miriam Makeba, 1960

The paintings of the 1950s and 1960s reflect Sekoto's gradual emotional withdrawal from South Africa. This is readily revealed in such paintings as *Basotho Women* and *Woman and Children*. Instead of developing his Parisian sketches, he painted South African township scenes over and over again. The tonalities and colour arrangements begin to change dramatically and the individualistic and distinctive characteristics of the people in his pre-exile paintings give way to anonymity and idealization. These township residents are portrayed as faceless, isolated and non-communicative. As Sekoto's memory dimmed and he was no longer stimulated by actuality he could not engage with the specific, and many of the paintings suggest a loss of direction, perhaps reflecting Sekoto's own uncertainties. An exception is a series of Blue Heads portraying idealized African females painted between 1960 and 1965. The paintings could well have been stimulated by the acclaimed arrival of the South African singer, Miriam Makeba, in New York in 1960. Photographs of her featured on the cover of *Time* magazine and elsewhere and inspired Sekoto to make several sketches of Makeba. He never met her. The sketches relate strongly to the Blue Head portraits; as an example,

Woman's Head, where the palette is limited to blue and white, with yellow or brown sometimes introduced for contrast.

In 1966 Sekoto accompanied his friend, the Brazilian artist Wilson Tiberio, to Dakar to attend the Congress of Negro Artists. Sekoto had won the competition to design a poster for this congress. He had expected Senegal, also being Africa, to be more familiar to him. He complained,

> it differs from ourselves in the South mostly because of the Muslim influence. It was also difficult communicating in their French. They speak a dialect which they mix with French.

Despite his desperate attempts to integrate and to learn, he felt like a foreigner, especially as the Senegalese found his South African Pedi accent amusing.

In June 1966 Sekoto and Tiberio were taken to a remote rural area called Casamance. Sekoto wrote that 'here people still retained their entire African way of living.'

Sekoto was enthralled by life in Casamance. It brought

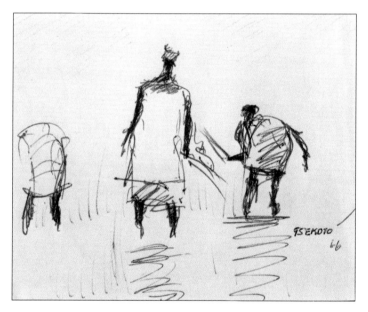

Senegal: Three Women at Ricefields, 1966

back memories of his early childhood when, as the son of a preacher, he had observed the tribal rituals of his Ndebele neighbours, without being able to partake in these activities. Now, in Senegal, he was offered an opportunity to watch at first hand the funeral rituals for a young boy who had died from a snake bite. Numerous sketches and paintings record

this event and suggest that Sekoto felt like a tourist; recording transient moments so as not to lose the memory.

Sekoto used ballpoint to make the sketches. Its fluid medium was maximized by Sekoto to create vigorous and dynamic drawings. He comments about his sketch *Dancing Figures: 2 Women,*

This is a particular dance of the women in Casamance. There was a gathering over the death of a young man bitten by a snake. A cow and a bull were sacrificed with a few chickens during this dance of the women. The whole ceremony lasted a day and a great part of the night. All the gestures and structures in the build of these people are very different from our women in South Africa.

Sekoto stayed in Dakar for a year, but was forced to return to France because of Marthe's illness. On his return he found Marthe bedridden, requiring frequent admissions to hospital. Sekoto kept house for the two of them and nursed her devotedly. He made many little sketches of the sur-

rounding streets: the market in the Rue de Buci and the cafés of St Germain des Prés. A self-portrait dated 1970 seems to foretell of the misery Sekoto was to suffer in the coming decade. Dr. Jacques Pernet, a general practitioner, who lived in Draveil, and a friend of Sekoto's for forty-four years, described him thus:

Senegal, Dancing Figures: 2 Women, 1966

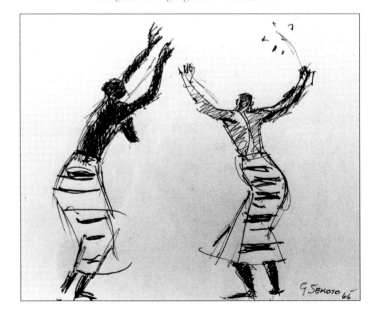

a sentimental and tender man, always in a dream, a pure creative artist, not at all interested in practical questions except to assume what he considered as his duty – in relation to Marthe and his family in South Africa.

During the 1970s he frequently drew on his memories of South Africa, painting scenes of township residents, busy with daily chores. Although he continued to use oils, gouache, which was less expensive, became a favoured medium. Many of these paintings were sent home for his brother Bernard to sell, as Bernard depended on Sekoto for financial assistance. Bernard had the added responsibilities of looking after their aged mother and his own family of four children.

During the 1970s Sekoto returned to themes he had favoured ten or twenty years earlier, but the colours and line differentiate them from his earlier paintings. Memories of Senegal, too, were to be repeated until his death. His last sketches often depict Senegalese figures walking in the streets of Nogent-sur-Marne.

Sekoto's mother died in 1979 and his brother in 1981. In 1982 Marthe finally succumbed to lung cancer and died in a hospital in Corbeil, near Paris. One can only try to imagine Sekoto's anguished feelings and his deep sense of loss and loneliness. After Marthe's death, his own life slowly began to fall apart. He was forced to leave the apartment they had shared for thirty years after his tenants had badly damaged the interior, and Sekoto was unable to pay for the repairs. Marthe had not left a will and consequently Sekoto had no legal claim to her apartment. The fact that he had made a significant financial contribution towards its acquisition and maintenance left him embittered and saddened. He began drinking heavily again and had another short stay in St Anne's hospital. On his discharge the Department of Social Security placed him in an old age home in Corbeil, outside Paris.

In 1983 while walking in the street, Sekoto was knocked over by a bus and sustained extensive injuries necessitating a five year stay in the unwelcoming surroundings of the Hôpital Dupuytren. Both legs were fractured and he was left with a permanent limp.

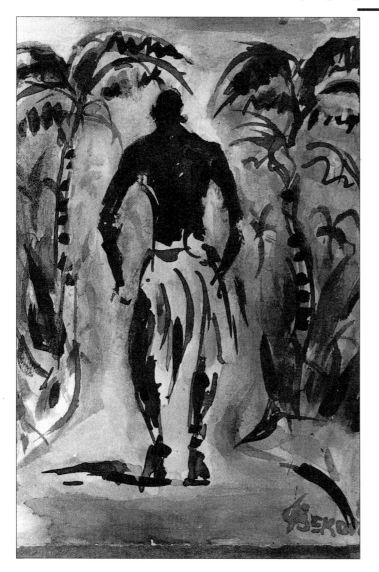

Memory of Senegal, 1988

He left hospital in 1987, forty years after his arrival in France and moved to the Old Age Home for Artists at Nogent-sur-Marne. This home, set in park-like surroundings, offered him true peace and security at last, something he had never really known since his childhood. In a letter to me he said:

> But Barbara if you had to know what I had to go through in life – still one shouldn't let complexities bar the way. I even try to avoid as much as I can to spit out all I had to go through, and still am experiencing. Life is not always an easy passage to glide through.

The publication of the book *Gerard Sekoto* in 1988 brought great acclaim for Sekoto's achievements. In November 1989 the Johannesburg Art Gallery mounted a comprehensive retrospective exhibition, which was subsequently shown at all the major centres of South Africa.

A collection of 320 drawings dating from 1938 to 1988

was purchased by the Johannesburg based daily newspaper, *The Sowetan*. The collection is housed at the galleries of the University of the Witwatersrand, Johannesburg and periodically is displayed all over South Africa. On 13 December 1989 Sekoto was awarded an honorary doctorate of letters by the University of the Witwatersrand. Sekoto declined the invitation to return to South Africa for the ceremony and the degree was conferred on him in absentia.

South African and international publishers then started to take notice of Sekoto's work. His paintings were chosen as book covers and as illustrations. He was also awarded the merit prize in an annual South African art competition – *Vita Now*, and he donated the prize money to a project to encourage art appreciation in black children. This concept was adopted

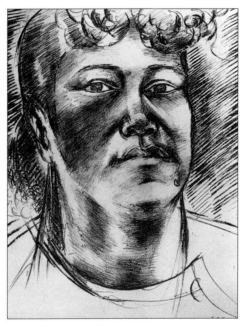

Portrait of Ann Gaspard, 1988

by the *South African Foundation for the Creative Arts*, and a *Gerard Sekoto Children's Day* has subsequently become an annual event held at municipal art galleries throughout South Africa.

In October 1990, the French Government conferred on Sekoto the award of Chevalier dans l'ordre des Arts et des Lettres, a fitting tribute from France for Sekoto's achievements.

In 1991 the Sowetan collection of Sekoto's drawings was exhibited in a Lutheran church in the northern Transvaal, and close to Khaiso, where Sekoto had taught in 1938. The exhibition aroused enormous interest amongst the 2,000 visitors, few of whom had ever seen an art exhibition before.

In 1992 the Clermont Art Society in Germany gave Sekoto their Lifetime Achievement Award.

Sekoto was found dead in his room on 20 March 1993 at 6.00 a.m. When the news of his sudden death became known in South Africa, glowing tributes to him appeared in all the newspapers. In July the collection of Sowetan drawings was chosen for exhibition at the Grahamstown National Arts Festival, the largest arts festival in the southern hemisphere, and has since been seen at all major South African art galleries.

In 1995 the South African Postal Services will feature Sekoto's paintings on nine stamps; belated but nonetheless official recognition of Sekoto's place in the art history of South Africa.

The impact of Sekoto's recent reintroduction into South African society, through his paintings, has been dramatic. Younger artists consider Sekoto's recognition to be a source of inspiration and testimony that persistence and determination finally yield rewards. A younger generation of authors have been inspired to write about Sekoto whilst the study of his art is now included in the schools curricula nationally. The publication of Sekoto's life story has been the catalyst for ongoing research into the lives of his contemporaries. In October 1994, the Johannesburg Art Gallery held a retrospective exhibition of the work of Ernest Mancoba and his wife, Sonja Ferlov, and George Pemba still exhibits frequently. These pioneer artists now enjoy their place in South African art history.

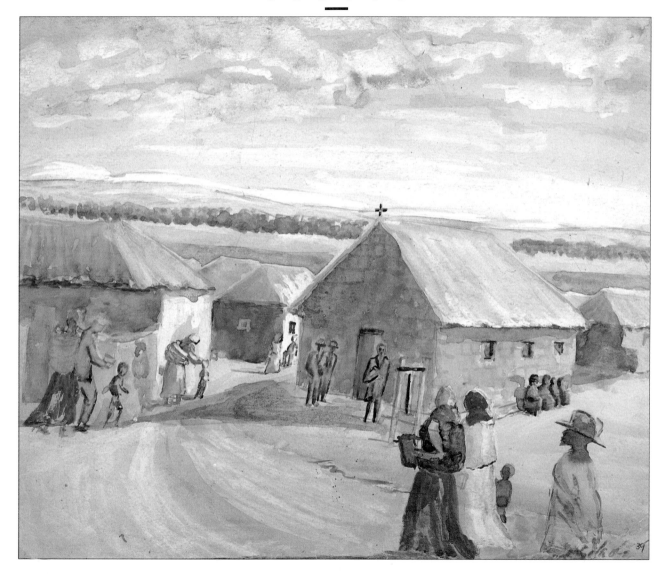

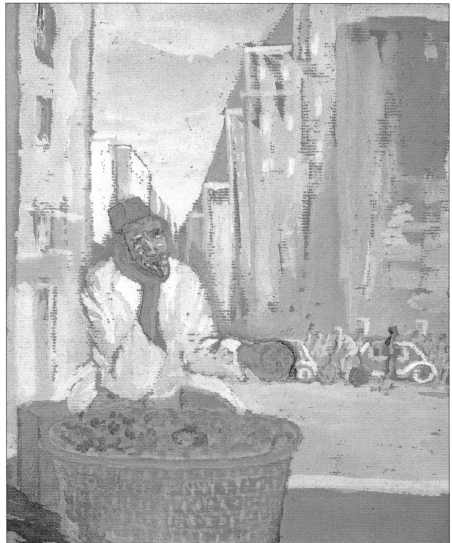

LEFT: LUTHERAN CHURCH AT BOTSHABELO, 1939.
'My father trained as a teacher but there
were no available posts. The missionaries
decided to "spread the word" so they per-
suaded him to become an evangelist. He
was sent to a farm called Wonderhoek
where he built a house and later a chapel.'
Photo: Peter Goodman

RIGHT: POVERTY IN THE MIDST OF PLENTY, 1939.
'I continued with much more vigour to
paint on brown paper, using poster colours
because they gave a bolder effect. I could
use big spaces which allowed me a more
free hand than when working on white
paper with watercolour.'

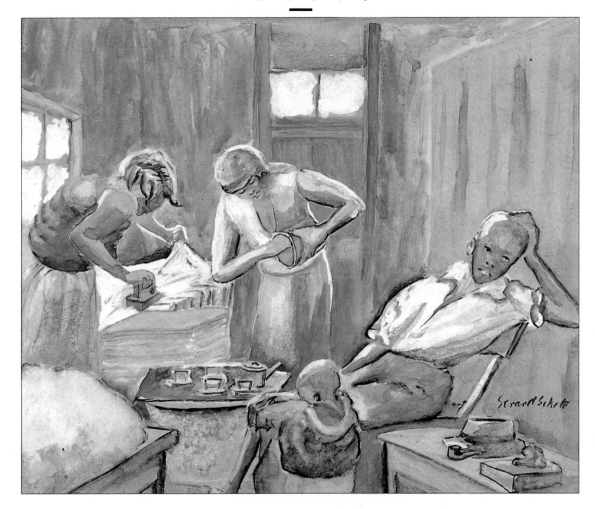

INTERIOR SOPHIATOWN, 1939.
'What I am in love with is not merely to be loved, but that love be the chain joining us all.'

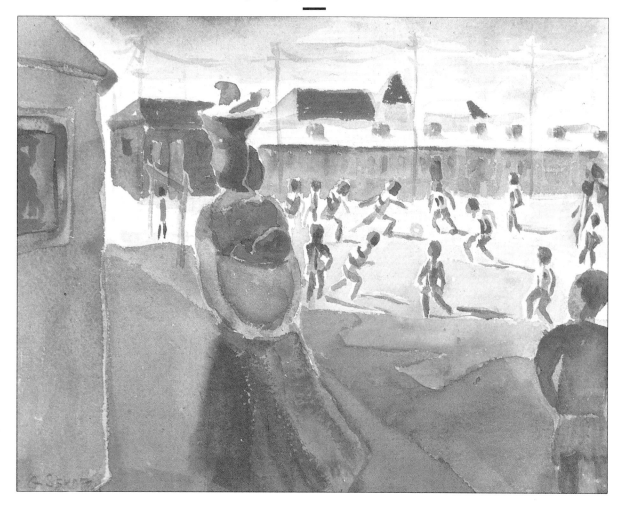

THE SOCCER GAME, 1939–40.
*'I love being in a group for a while and later getting away – either watching from
a distance to read gestures and movements, or merely being myself.'*

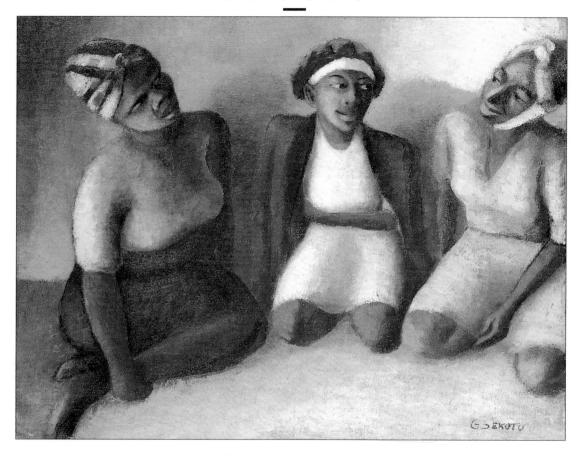

THREE WOMEN, 1940–42.
'I have never had any intention of getting married and having children . . . It was always solitude and freedom of mind that attracted me.'

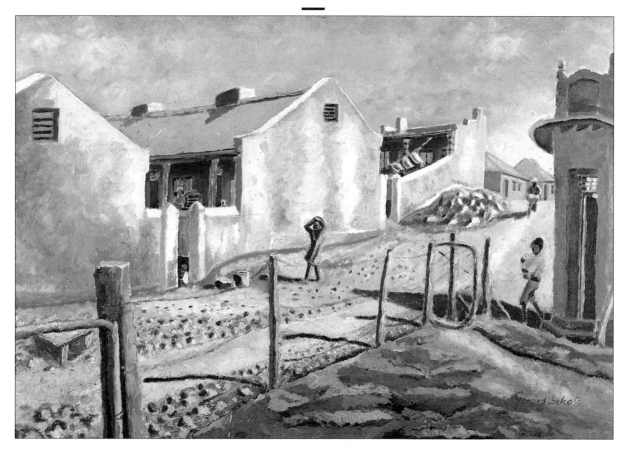

YELLOW HOUSES – SOPHIATOWN, 1940.
'. . . the inquisitive eye was attracted by the wall covering the illicit beer holes . . .
These colours of yellows had always attracted my eye. Also the reds of the roofs – all
mingled with varied browns of rusted tins lying around, upon the yellow sun-hued
earth with the rolling stones of many shades which were often used as seats by
women chatting through the day.'

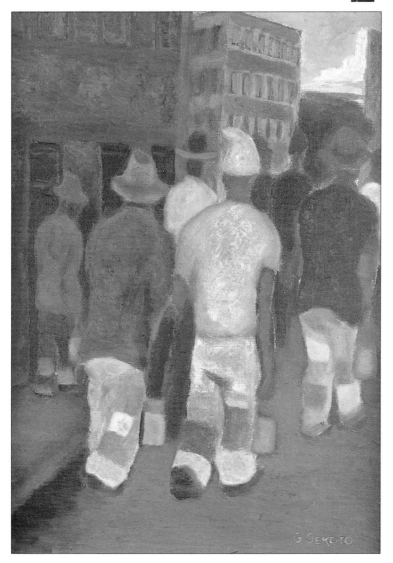

LEFT: THE MINERS, 1940–42.
'These people are workers being herded to the mine compounds which leaves them in a state of imprisonment, hence the absence of any happiness!'

RIGHT: CYCLISTS IN SOPHIATOWN, 1940–42.
'I still had in mind to visit Cape Town which I imagined to be very different in ways of living from Johannesburg. I started to collect paintings for a show which would pay for my trip to Cape Town and to stay there for a while.'

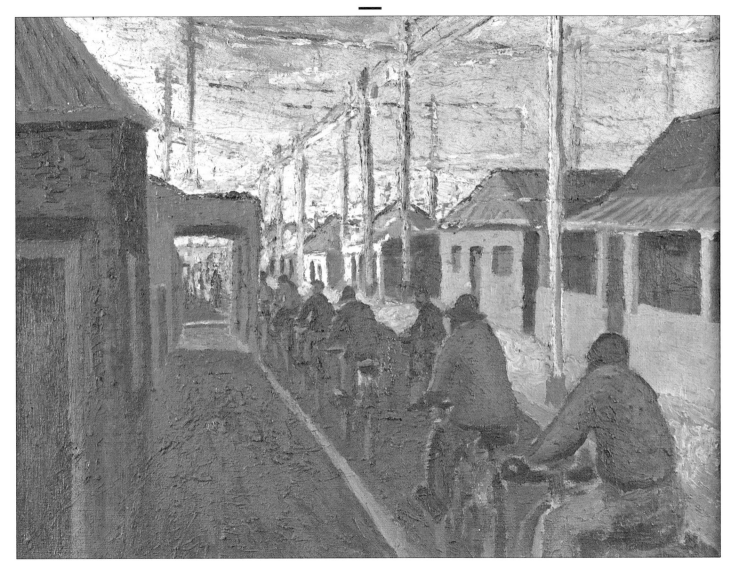

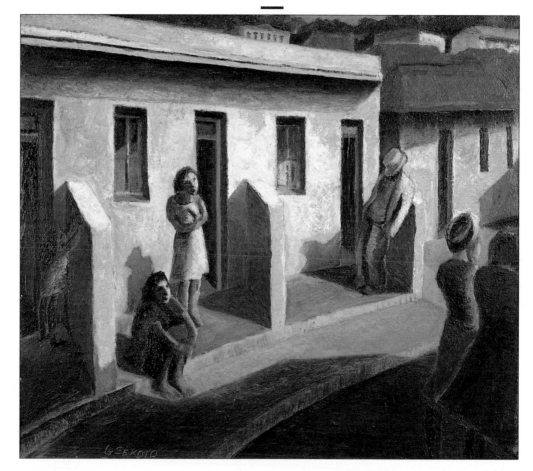

HOUSES: DISTRICT SIX, 1943–45.
'I lived on the edge of District Six – the "coloured" area. It was poverty stricken . . .
Several members of one family were squeezed into one place, obliged to sleep and eat
in the same room which was hardly ventilated and awfully dilapidated, while in the
backyard several families had to share one toilet.'

CHILDREN PLAYING, 1942–45.
'*Since it was the law of the country that whites topped the list, that would sometimes create embarrassment amongst family and friends. A child could be the whitest in the family in which case he could be tempted to "play white" and shift into the more advantageous awareness of life.*'

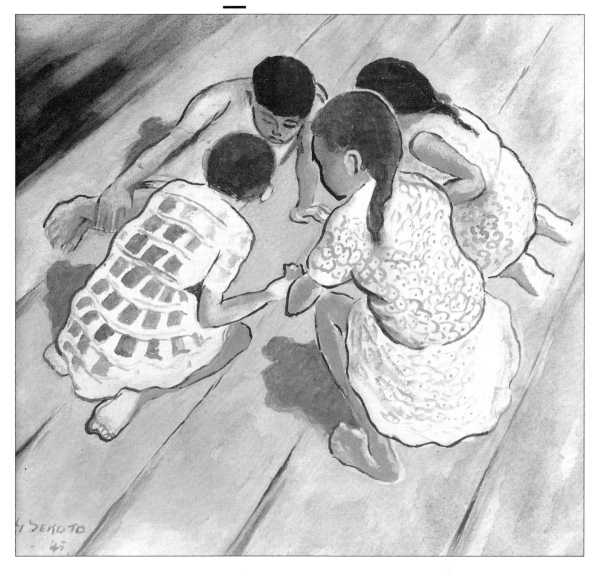

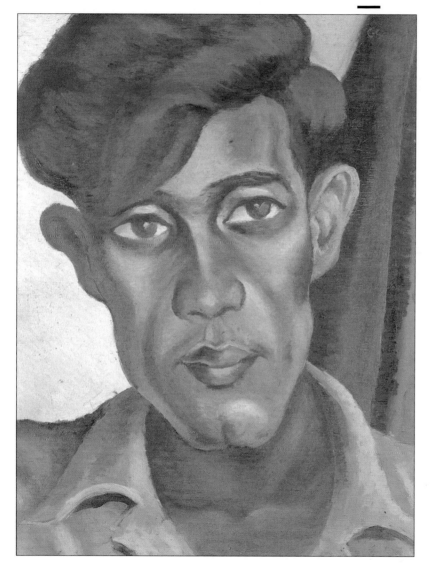

LEFT: PORTRAIT OF A CAPE COLOURED SCHOOL
TEACHER – OMAR, 1942–45.
*'Omar – I forgot his surname, however his name
was that of a Malay. I am sure he would be proud
if we could trace him.'*

RIGHT: PRISONERS CARRYING A BOULDER, 1942–45.
*'Should my art ever hit into a peeping eye of some
politics, then its just bad luck to the victim, since I
have merely expressed my true feelings as an
artist. I hate politics – everyone wanting to be
better than the other and hence using any means.'*

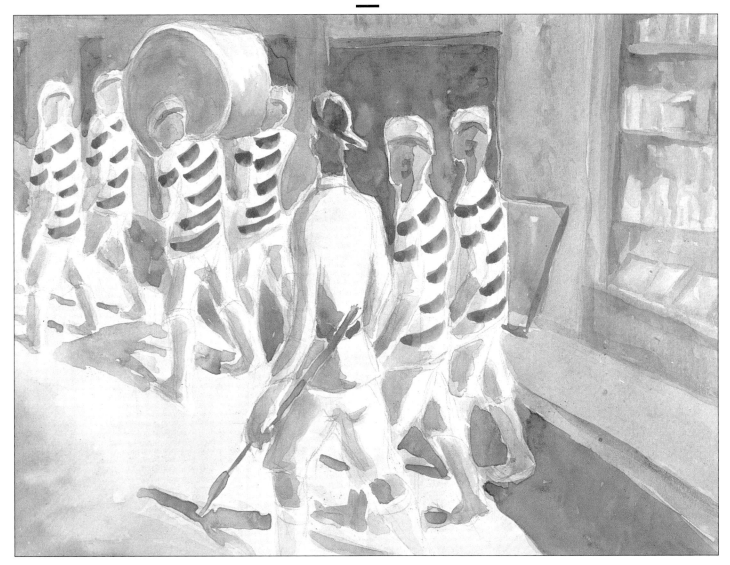

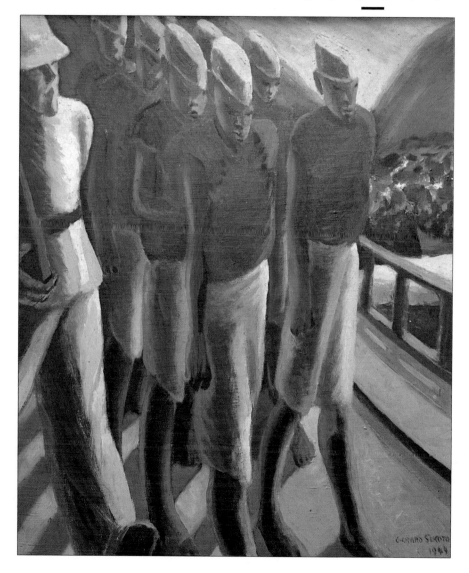

PRISON YARD, 1944.

'I hovered within arms length of the more dangerous hideouts of District 6. I would make quick sketches in such a manner that an observer would imagine I was noting down some forgotten names or articles I needed to buy. Shortly thereafter I would return to my studio to work up those sketches.'

The Wine Drinker, 1943–45.
'Young coloured people would be seen loitering around without jobs, not able to go to school because their parents were without means, so all they had to do was to hustle to drink cheap wine and smoke. The community was neglected and cut off from society. Mothers had to make ends meet in the most complicated way, while the fathers were either in prison, drinking or pushing drugs with friends on street corners.'

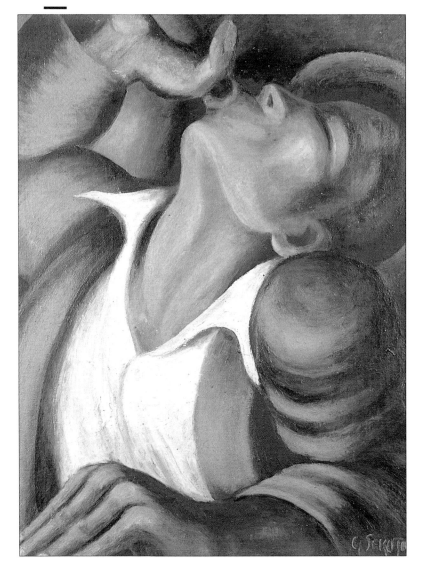

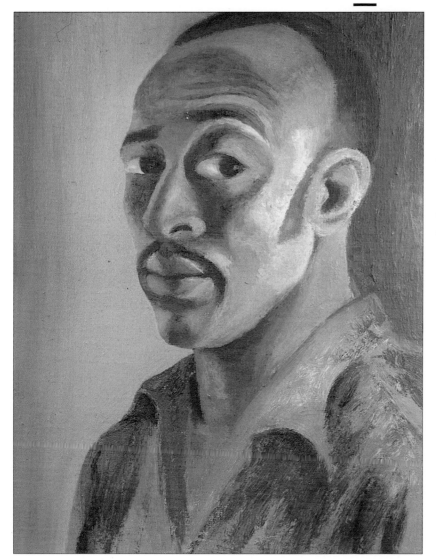

SELF-PORTRAIT, 1946–47.
'What you are reading from my expression is not fear, but mostly mistrust and deep agony about contradicting attitudes amongst people. I do not have a particular fear, but am looking into the future of our country with much anxiety, yet fully determined to live this life as everybody does – through using one's own personal walking sticks.'

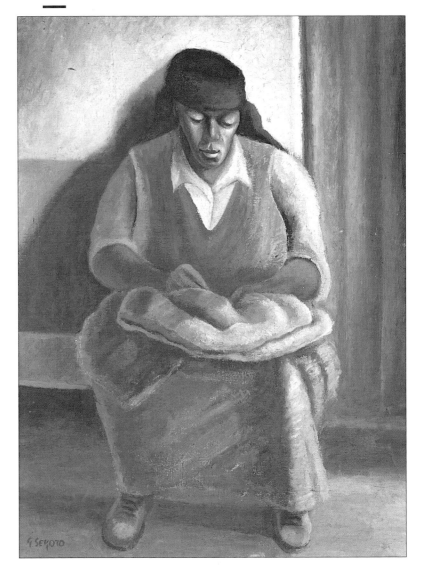

PORTRAIT OF ANNA, THE ARTIST'S MOTHER, 1946–47.
'My mother was a very serene lady. She would not just shout out anything. She would smile easily but always kept her inner thoughts to herself. That was how I could depict her from my heart's depth.'

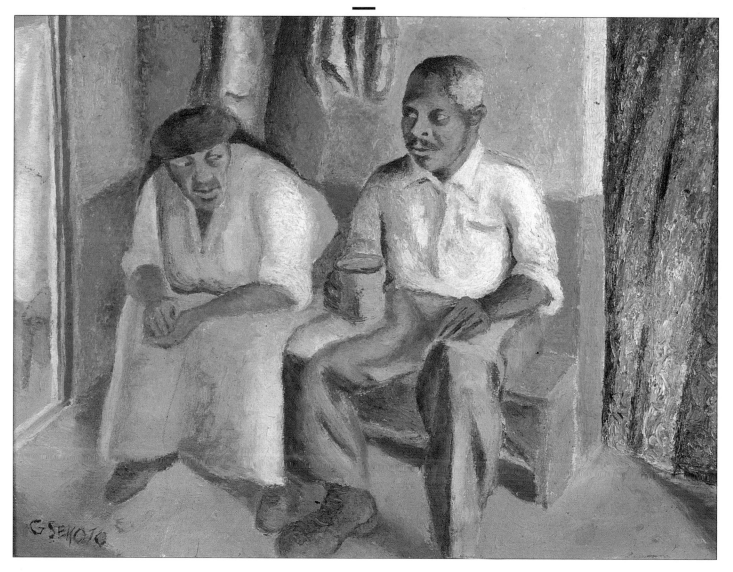

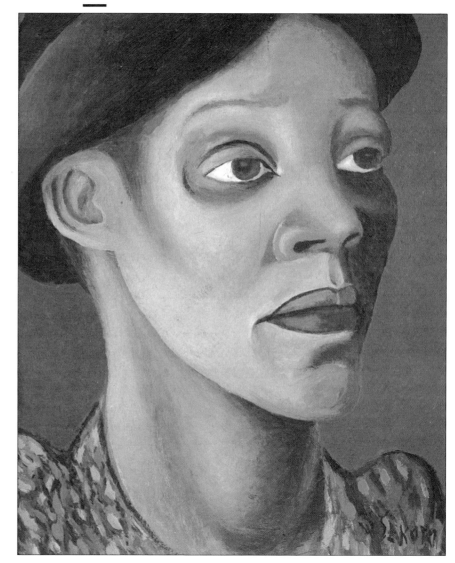

LEFT: THE ARTIST'S MOTHER AND STEPFATHER AT
HOME IN EASTWOOD, 1946–47.
*'My mother was a person who would mediate
and digest matters before speaking out. But
my stepfather was very energetic and always
ready for action. My interpretation was of the
woman protective and bearing all, to produce
on and on what life is and has always been,
while having to guess and hope for the future.
The stepfather is always ready to take the
bull by the horns.'*

RIGHT: MARY DIKELEDI SEKOTO, 1946–47.
*'My sister-in-law, Mary Dikeledi, is not easy
to allow for in a pose. However, we got on
well and I finally made her sit for a very
short time. She is a tough character, but I
could moderate her into a mild mood, even of
gaiety, whenever she was in a contradictory
state.'*

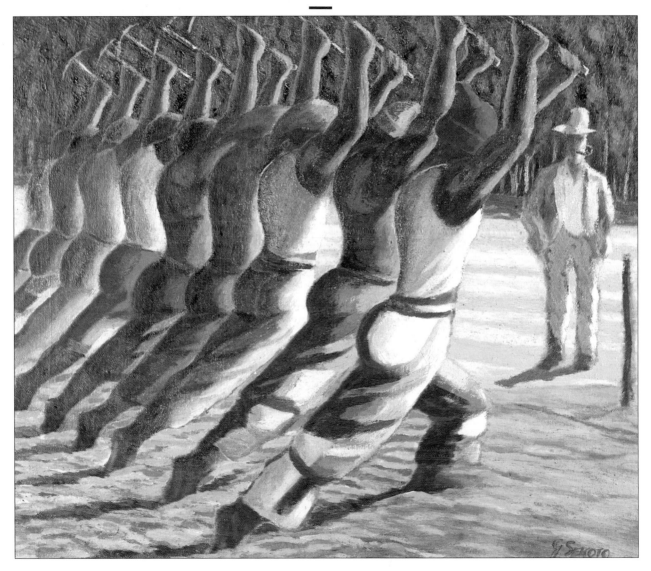

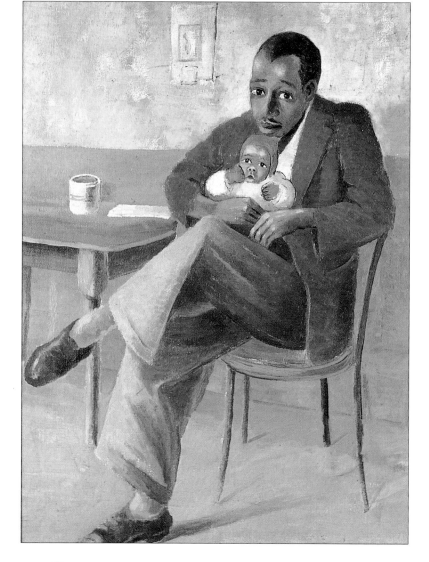

LEFT: SONG OF THE PICK, 1946–47.
'The warden, with his hands in his pockets while smoking his pipe, thinking himself the power, yet being overpowered by the "Song of the Pick" with strong rhythm which he can clearly hear so that it diminishes his thin legs into nothingness.'

RIGHT: THE PROUD FATHER, MANAKEDI (NAKY) ON BERNARD SEKOTO'S KNEE, 1947.
'The most important memory usually remains for a long time, if not for as long as life continues.'

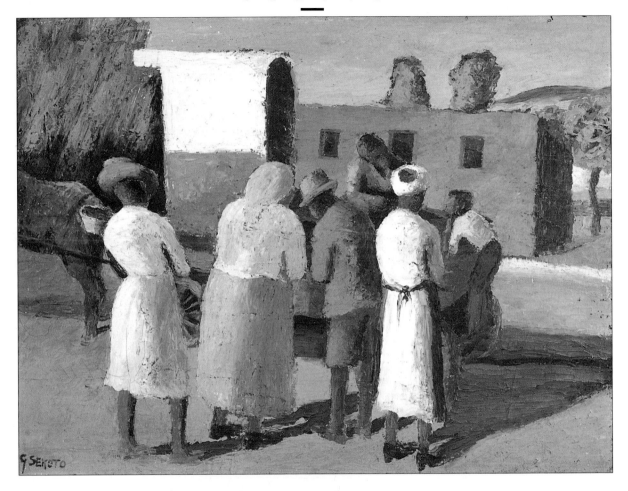

THE DONKEY CART, EASTWOOD, 1946–47.
*'I belong to all the people of my land of birth and they also belong to me. I think
that fact is being made clear in the productions and in my determination to further
on my work in their name.'*

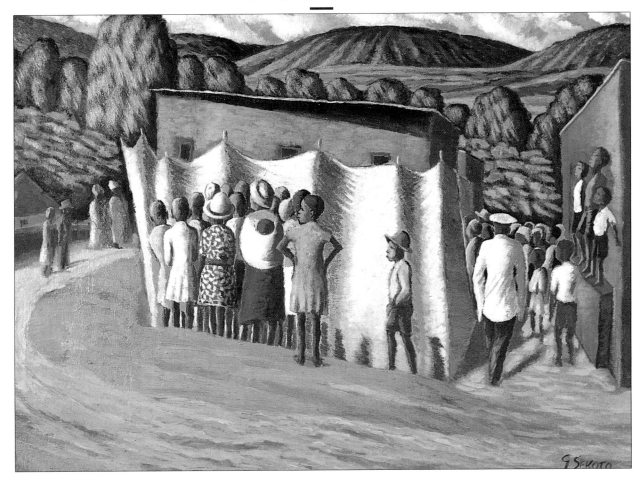

SIXPENCE A DOOR, 1946–47.
'When I shall be gone the trace which I shall have left behind shall remain deeply
engraved into any human fertile soil and stained into time as well.'

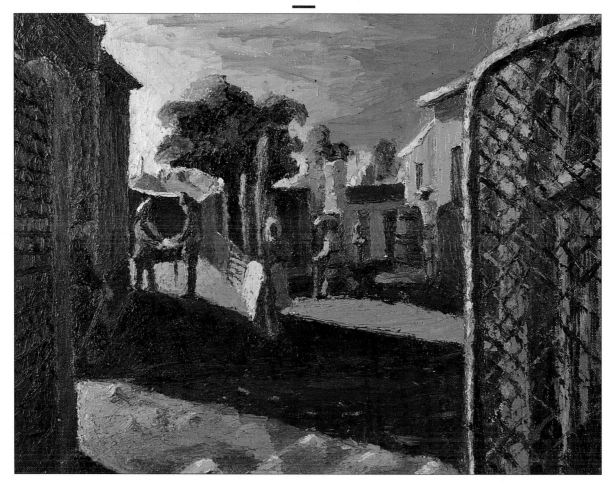

BEYOND THE GATE, 1946–47.
'I am no politician yet I hate apartheid because it is against my philosophy in life.
This I could repeat even if I happen to be one day at home on a visit.'

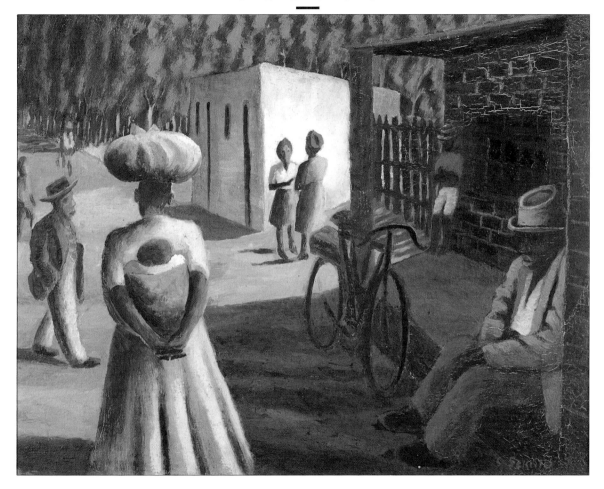

Outside the Shop, 1946-47.
'Do not always be too ready to take in every spoken word – before having judged
and read in between the lines! You have already gone through a number of lessons to
keep you on the alert, so have I.'

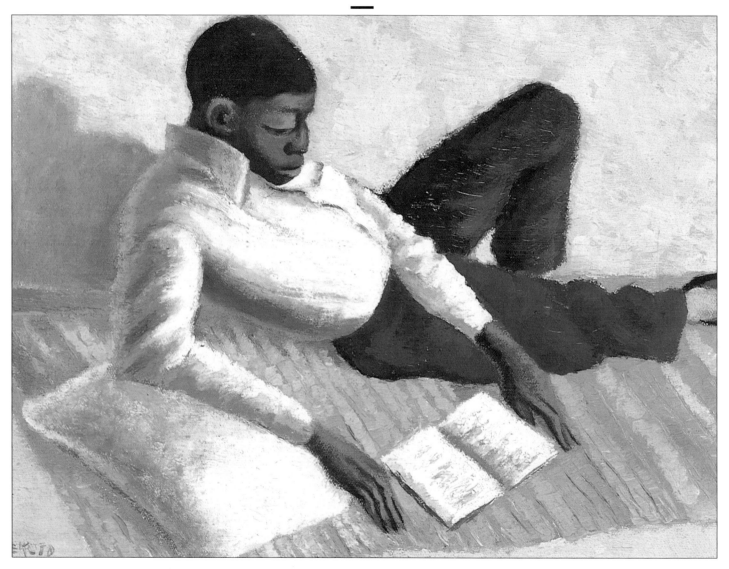

LEFT: PORTRAIT OF A YOUNG MAN
READING, 1946–47.
*'The young man reading has
also been done in Eastwood,
but I no longer remember who
it had been, since most of the
time – my models were not
aware.'*

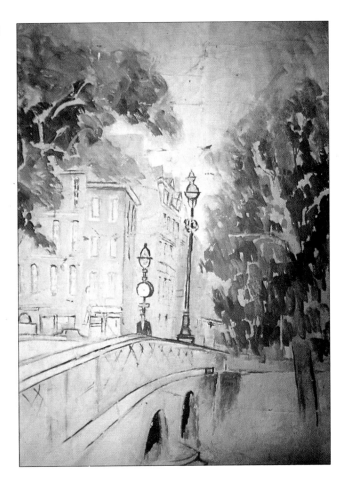

LEFT: PARIS: PONT MARIE,
1948–49.
*'Leaving South Africa's gold
mines, with apartheid, did not
mean running after any golden
mines in Paris, but finding
poverty instead. On the
contrary, I was after golden
minds . . . My purpose was in
search of listening and
exchanging ideas with other
artists from different countries –
in short, communication.'*
Photo: Marie Féral Descours

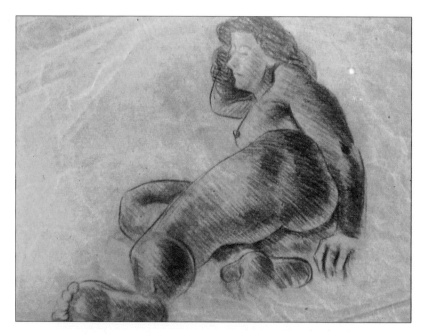

NUDE: SKETCH FROM L'ACADÉMIE DE LA GRANDE CHAUMIÈRE, PARIS, 1948.
*'At the Académie de la Grande Chaumière . . . it was that Parisian atmosphere which
was dominant: to be wise, "sage" and avoiding being ridiculed. This philosophy has
taken me a long time to try to adapt to myself, as it made me feel unnatural. I will
never be fully trained in that direction.' Photo: Marie Féral Descours*

BASOTHO WOMEN, 1952–53.
'*My stylizing came out of a fear of the jungles all around. Varieties of the styles in the place made me feel stubborn not to lose my personality. I therefore thought to take something apart, hence the rounds and ovals – trying to think as far back as possible in my life.*'

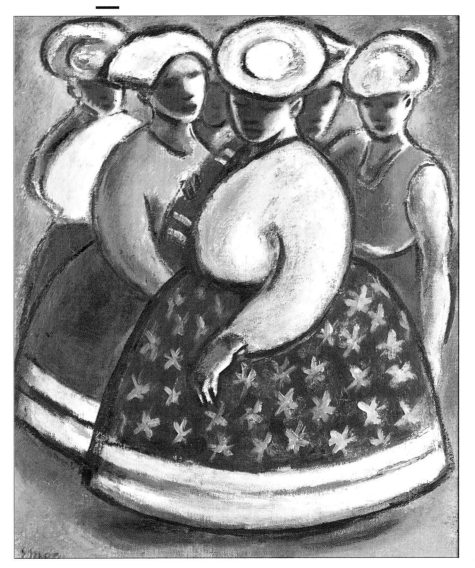

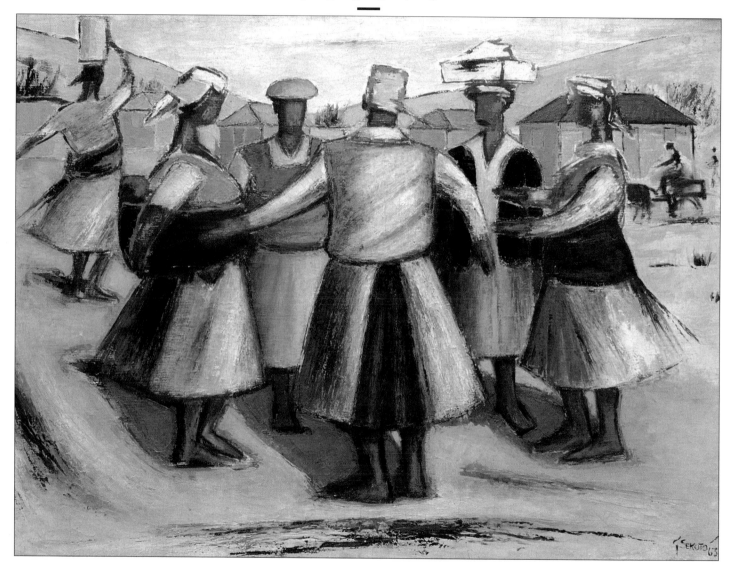

LEFT: TOWNSHIP GOSSIP, 1963.
'I do know where I come from, what I am and what my purpose is. There is no loneliness or failure to integrate into the Parisian way of life. I left home of my own free will and purpose and with time and love to acquire that for which I have come here. No one can become an entire Parisian after having lived a great part of his life in another country.'

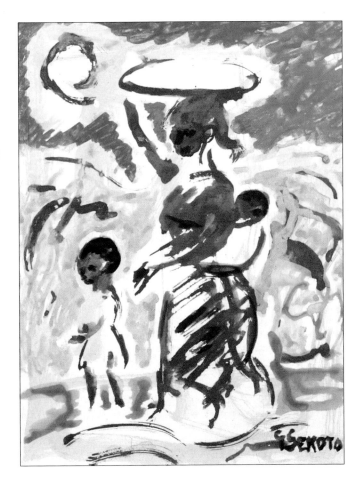

LEFT: WOMAN AND CHILDREN, 1953–55.
'I remember as a child being happy to be taken to the small town of Middelburg with my aunt . . . holding my tiny hand. We were not allowed by law to walk on the pavement because we were black.'
Photo: Dr S Pelage

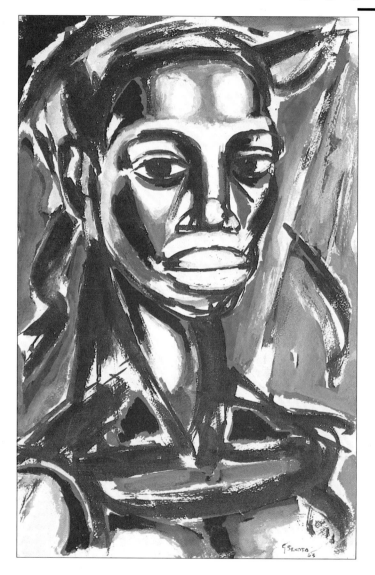

LEFT: WOMAN'S HEAD, 1963.

'Most of the time it is mainly white female beauties being painted by artists. I felt there are also various beauties in all races and that I could express the beauty of those I know best. I used blue because it was sufficiently strong for making a contrast with warmer colours.'

RIGHT: THREE SENAGALESE WOMEN, 1968.

'The slow elegant movement of the people was mostly like that of a fairy tale to me. I did not speak the language to be able to extract the real feel of the people in my own way. The women are stately, artistocratic and tall. They walk as though they have no concern at all with their surroundings.'

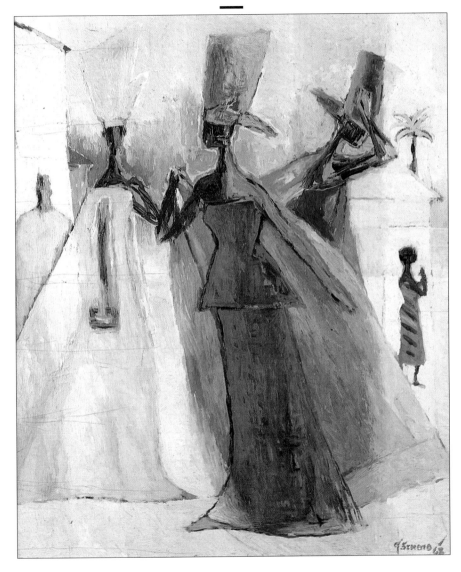

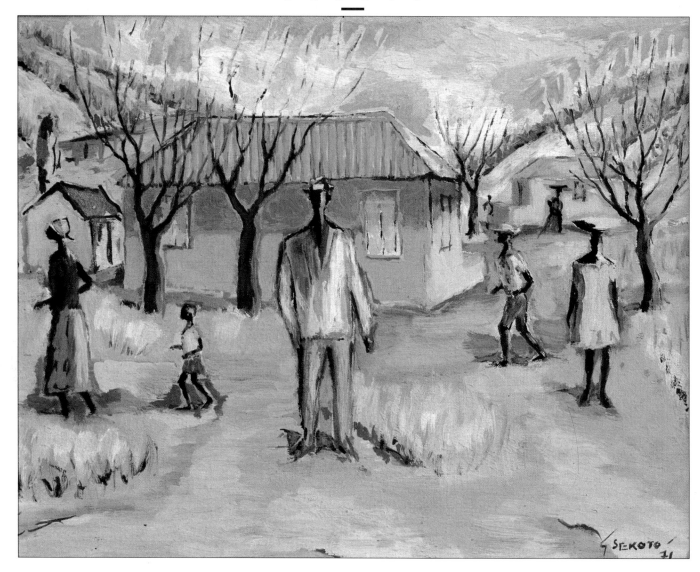

LEFT: TOWNSHIP SCENE, 1971.
'This work is a little different from the earlier techniques and sometimes also in colour. Although both retain the endeavour to express the movement and the desire to search into the innermost feelings of my subjects.'

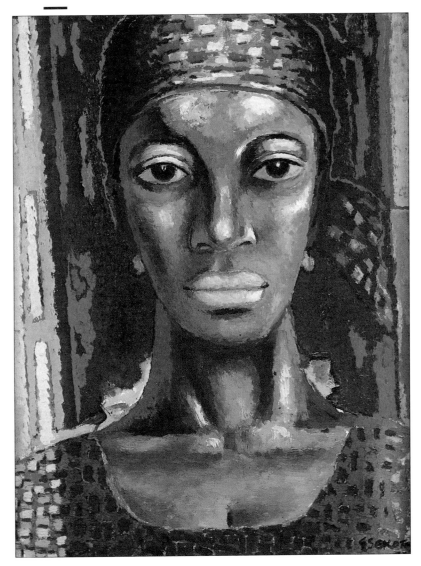

RIGHT: WOMAN WITH A PATTERNED HEADSCARF, 1975.
'The hardship of Van Gogh's life was no discouragement to me towards the pursuit into my art and living among other artists from different countries, since all along my life had never been a particular chase into material wealth, although I do require means to acquire my materials.'

If I were to go back after forty-one years of absence, I would not be able to make a contribution, whilst visiting all those places I've known and trying to read the changes that have taken place. The crowds would not leave me alone. They would wish to accompany me wherever I went, just to watch this creature which has been away for so long. Curious people of all types together with journalists and writers, would not cease to hover around me. Worse still could be the differing hungry political groupings and individuals – each with his own particular interpretation of my sudden return, more especially just after the release of Mandela. Some would conclude I want to take advantage of his release and use it to receive my personal glory. In all I'd become a common victim to the many diversities in the country.

As far as you are concerned, there couldn't be any danger, but in several cases I could be the victim without protection. I know of the side which is not open to you to which you could become a victim. I would not go home for anything glittery to decorate looks or glorify whatever I might have done, since that is not my pursuit in life. Therefore the best thing and the most prudent is to remain here at Nogent-sur-Marne.

GERARD SEKOTO